TIM JEFFS ART
— Animal Sketches —

Australian
Wildlife

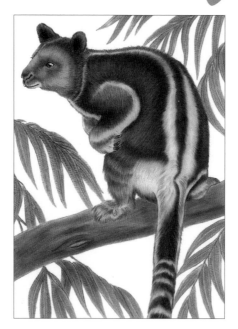

ANIMALS OF THE WORLD Coloring Book Series

For Jane, Jenna and Harrison

Dedicated to all of the wonderful colorists who have supported my art and made my drawings
more beautiful with their colors, and all the precious creatures that we live among.
A special thank you to Jo Warren for all of her continued support and beautiful colorings
and lesson that make this book so much more special!

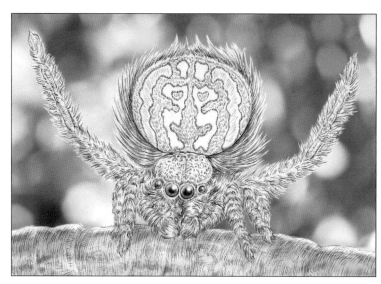 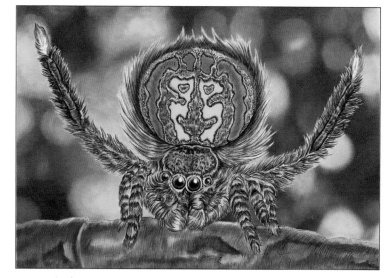

Grayscale coloring page before... ...and after you bring it to life with your colorful imagination!

Tim Jeffs Art
376 East Madison Avenue, Dumont, NJ 07628

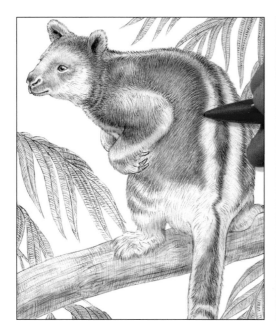
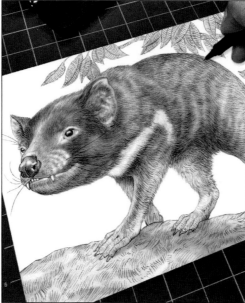
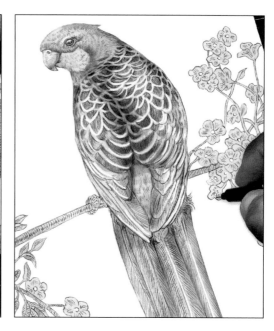

Sketching Australia's Wildlife

Australia's Wonder and Beauty. I've never been to Australia, but it's a country I can't wait to visit and experience. So for this introduction I want to give the stage to a true Aussie. Jo Warren, whose coloring expertise are involved in the beautiful colorings in my books coloring lessons, is a native Australian. She is someone who can best describe the natural beauty of this unique and stunning land.

There are so many things that I love about Australia and the unique and diverse wildlife is one of my favorite things about this beautiful country. So many of the species that live here are not found anywhere else in the world. Every day was an adventure for me with so much wildlife to discover right on my doorstep. There were times I would sunbathe in my garden and the lizards would come and join me to soak up the rays! When Tim said he was going to create a coloring book on Australian animals I said "Fair Dinkum mate" and I knew he was going to do us Aussies proud and he certainly has captured the essence of Australia's amazing wildlife in these 15 drawings that we all get to color! – **Jo Warren**

In this coloring book I've drawn the animals on various backgrounds. Some of the animals I've drawn in their natural environments, some on black backgrounds to enhance your colors and make them pop. I hope this will give you further coloring creativity options to have fun with. I hope you enjoy coloring this group of Australia's animals as much as I enjoyed drawing them, and I know that with your colors, you will bring these beautiful Aussie animals to life!

Coloring the Koala

On the next page I will walk you through the coloring of the Koala which is on page 9 of this coloring book. You can't think about Australia without a Koala coming to mind. Mistakenly called bears, Koalas are marsupials. Their name comes from the Dharug word gula, meaning no water since they were thought to not have to drink due to the fact that they don't come down from the trees they live in often. I hope you enjoy coloring this adorable animal!

❯ Supply List

In this lesson, Faber Castell Polychromos pencils were used, (pencil numbers are listed below) but you can use any brand with similar colors.

1) The coloring page can be found on page 9

2) Colors. Faber Castell Polychromos pencils:

283 Burnt Sienna
152 Middle Phthalo Blue
231 Cold Grey III
274 Warm Grey
235 Cold Grey VI
177 Walnut Brown
166 Grass Green

Copic Sketch Markers:
YG13 Chartreuse
E43 Dull Ivory

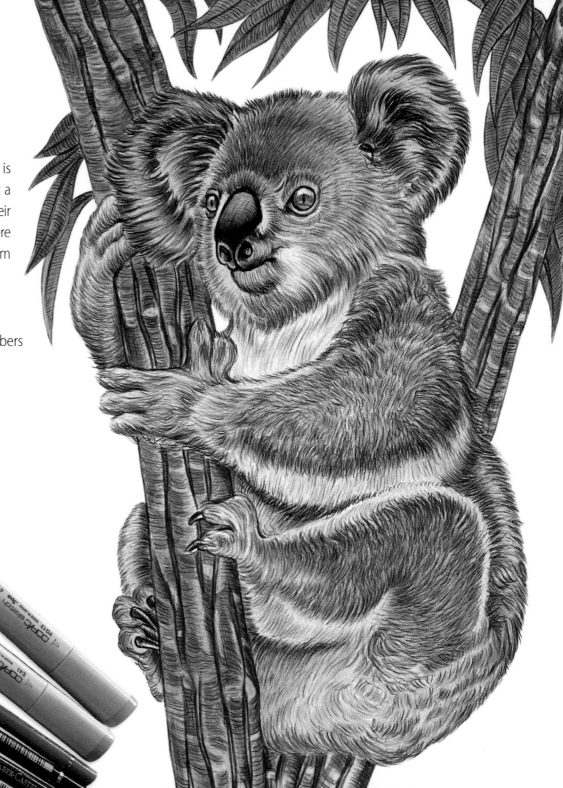

Koala

Making your Koala come to life with color

Step 1. To achieve a soft look to your Koala's fur make numerous strokes in the same direction as the lines in the drawings. Start with a base layer of Warm Grey and continue by adding Cold Grey VI and finally Burnt Sienna on top.

Step 2. Using Middle Phthalo Blue to color in the Koala's eyes. Then using a pink colored pencil (any will do) add a little pink to the mouth, nostrils and the small rings around the eyeballs.

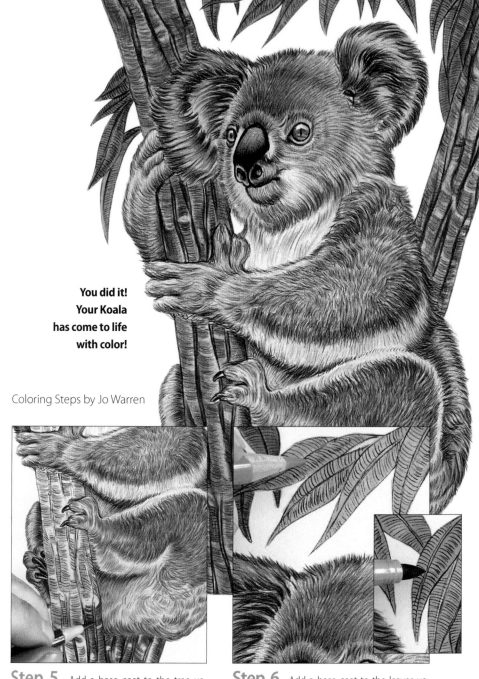

**You did it!
Your Koala
has come to life
with color!**

Coloring Steps by Jo Warren

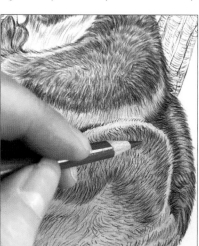

Step 3. The more stokes the better when it comes to coloring fur. Using Warm Grey build up the areas of the body, arms and legs. Darken the other edges while leaving the center areas lighter.

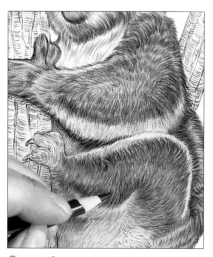

Step 4. Continue to build up and darken the fur using Cold Grey. The darker you get the more your Koala will appear 3 dimensional and soft and fluffy.

Step 5. Add a base coat to the tree using the Dull Ivory Copic Sketch Marker. Darken in the cracks and crevices of the bark using Walnut Brown.

Step 6. Add a base coat to the leaves using the Chartreuse Copic Sketch Marker. Finally darken the edges and center of the leaves using the Grass Green and Burnt Sienna colored pencils.

Spreading Awareness Through Coloring

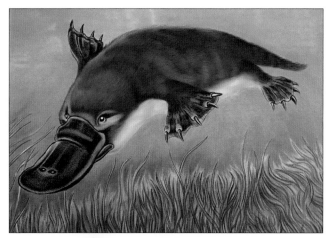

 Platypus
Near Threatened

I truly believe that raising awareness through the sharing of my artwork is a fantastic way to educate people about conservation. And coloring animals is a beautiful way to learn about them as you enjoy a relaxing and fun pastime. On the following page, I listed the animals in this book statuses on the *International Union for Conservation of Nature's (IUCN)* conservation list. I think it's important to include the *(IUCN)* conservation list in my books so people understand the classifications more clearly. To the right is an overview of the IUCN's conservation list, which breaks animals' conservation statuses into several categories. Knowing what these categories mean and the animals that are included in them is extremely important. **Together through art we can change the world!**

Tim Jeffs
Animal Artist

The list consists of 7 categories. From Least Concerned all the way to Extinct. Here are the definitions of each category:

- **LEAST CONCERN (LC):** A species that has been evaluated but not qualified for any other category on the list.

- **NEAR THREATENED (NT):** A species that may be considered threatened with extinction in the near future.

- **VULNERABLE (VU)**: A species likely to become endangered unless the circumstances that are threatening its survival and reproduction improve.

- **ENDANGERED (EN):** A species that is considered very likely to become extinct.

- **CRITICALLY ENDANGERED (CR):** A species that is facing an extremely high risk of becoming extinct in the wild.

- **EXTINCT IN THE WILD (EW):** A species that is only known by living members kept in captivity or as a naturalized population outside its historic range due to massive habitat loss.

- **EXTINCT (EX):** A species that has been terminated.

Learn about *Australian Wildlife*

Before you start coloring, it's important to learn about the animals in this book and their conservation status.

❯ **Bilby** A nocturnal animal that lives in Northwestern and Central Australia the Bilby was once widespread across 70 percent of mainland Australia but is now considered a threatened species.
Conservation Status: Vulnerable

❯ **Blue Tongue Lizard** Native to Australia they are known to live over 30 years and are very adaptable to any habitat. Their diet consists of garden pests which makes them beneficial in residential areas.
Conservation Status: Least Concern

❯ **Cassowary** A solitary bird which lives in Northern Australia it is related to the emu, ostrich and Kiwi. They are known to be aggressive and dangerous due to being equipped with lethal dagger-like claws and having a very powerful kick.
Conservation Status: Least Concern

❯ **Crimson Rosella** A medium-sized beautifully colored parrot that is native to Eastern and South Eastern Australia. They live in mountain forests.
Conservation Status: Least Concern

❯ **Dingo** A light tan colored medium sized canine with a lean body adapted for speed. The Dingo's habitat covers most of Australia. They live and hunt in family packs. **Conservation Status:** Least Concern

❯ **Freshwater Crocodile** A relatively small crocodilian which are found in Western Australia, Queensland and the Northern Territory. Males can grow to 9 feet long and weigh up to 150 pounds.
Conservation Status: Least Concern

❯ **Galah** Found throughout Australia it is also known as the Pink and Grey Cockatoo and Rose-Breasted Cockatoo. They have been recorded to live up to 72 years of age.
Conservation Status: Least Concern

❯ **Kangaroo** Indigenous to Australia and New Guinea Kangaroos are marsupials and their population is estimated at over 30 million. They have large powerful hind legs for leaping and can reach speeds up to 43 mph.
Conservation Status: Least Concern

❯ **Koala** Native to Australia they live in the Eastern and Southern regions. Their closest living relative is the wombat. Their habitats have been fragmented and reduced by urbanization and drought leading to their loss in numbers.
Conservation Status: Vulnerable

❯ **Peacock Spider** Native and widely distributed in Australia they are only 5mm in body length which is about the size of a grain of rice. Males have the colorful abdomen flap used during courtship.
Conservation Status: Least Concern

❯ **Platypus** Found in Eastern Australia and Tasmania they are an egg-laying mammal. Platypus means "flat foot" in Greek. They have an ankle spur that delivers venom. Conservation methods are helping their recovery. **Conservation Status:** Near Threatened

❯ **Quokka** Found on Western Australia's mainland and islands they are the size of a domestic cat and are a small macropod which have been given the name "the world's happiest animals" due to their smiling appearance. **Conservation Status:** Vulnerable

❯ **Sugar Glider** A nocturnal gliding possum that is native to Southeastern Australia, Queensland and New South Wales. They have very large eyes that help them see at night. They have been known to glide up to 55 yards. **Conservation Status:** Least Concern

❯ **Tasmanian Devil** A marsupial that was only found on the island of Tasmania. Recently reintroduced to mainland Australia as breeding populations. Only 15,000 remained in the wild as of 2008. Conservation efforts are hopeful for their survival.
Conservation Status: Endangered

❯ **Tree Kangaroo** Found in far Northeastern Queensland they are marsupials that thrive living in the rainforest's treetops. Their numbers have fallen due to hunting and habitat destruction.
Conservation Status: Threatened

Australian *Wildlife* Index

Bilby 1

Crimson Rosella 4

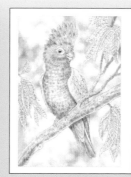

Gahah 7

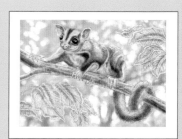

Peacock Spider 10

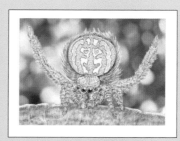

Sugar Glider 13

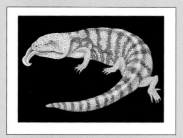

Blue Tongue Lizard 2

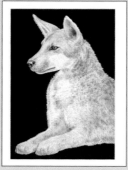

Dingo 5

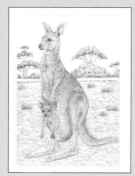

Kangaroos 8

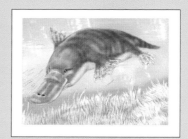

Platypus 11

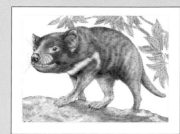

Tasmanian Devil 14

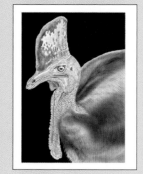

Cassowary 3

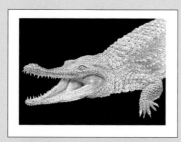

Freshwater Crocodile 6

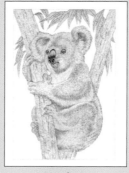

Koala 9

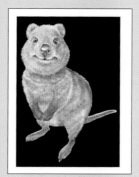

Quokka 12

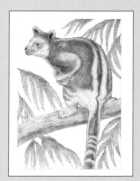

Tree Kangaroo 15

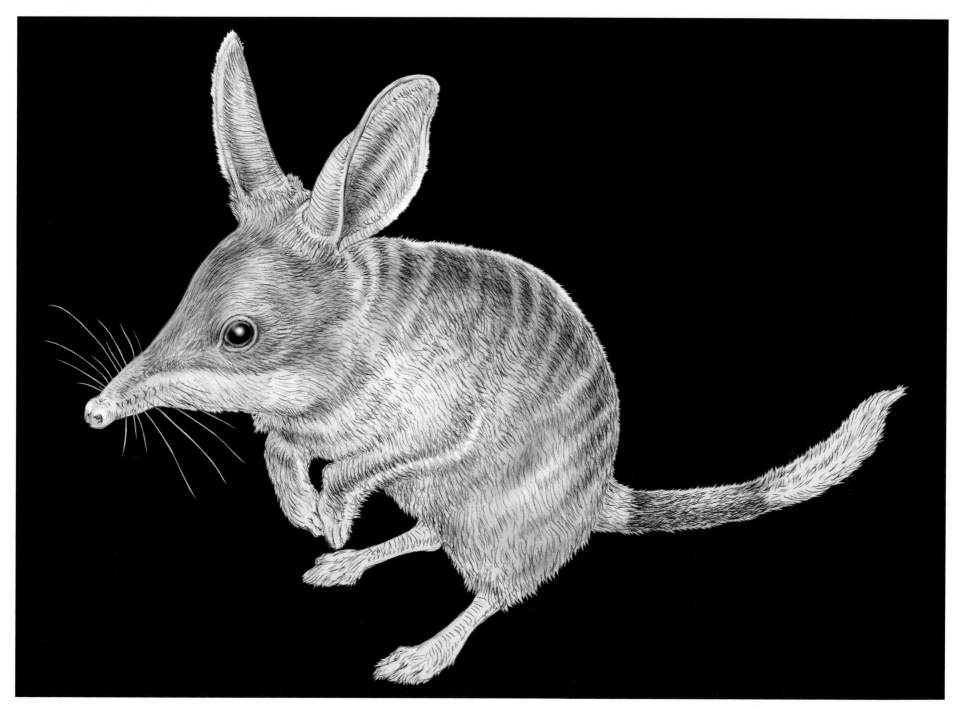

Bilby

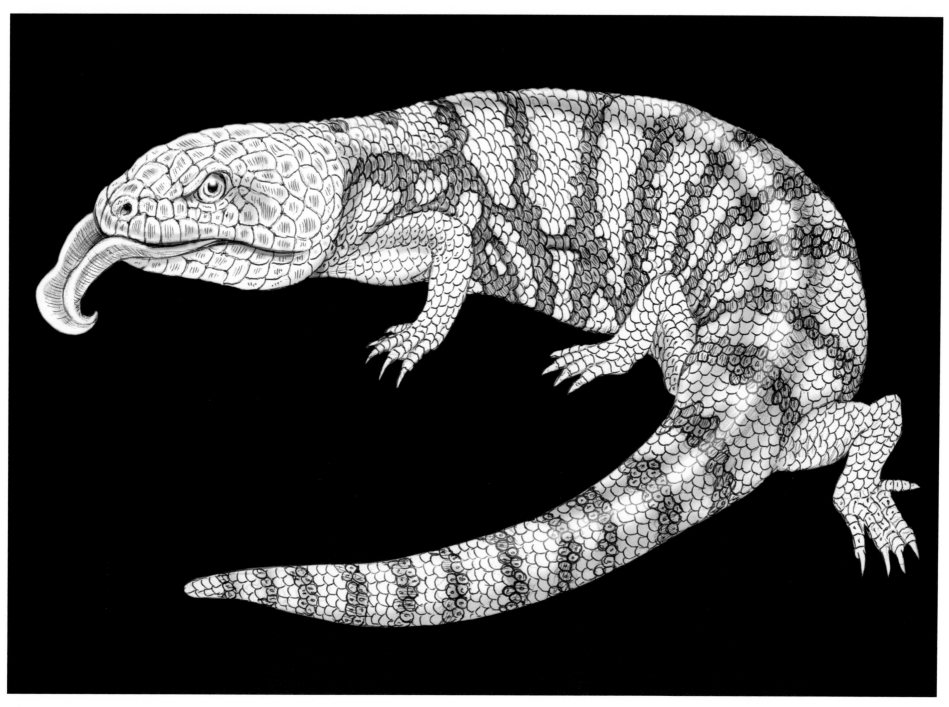

Blue Tongue Lizard

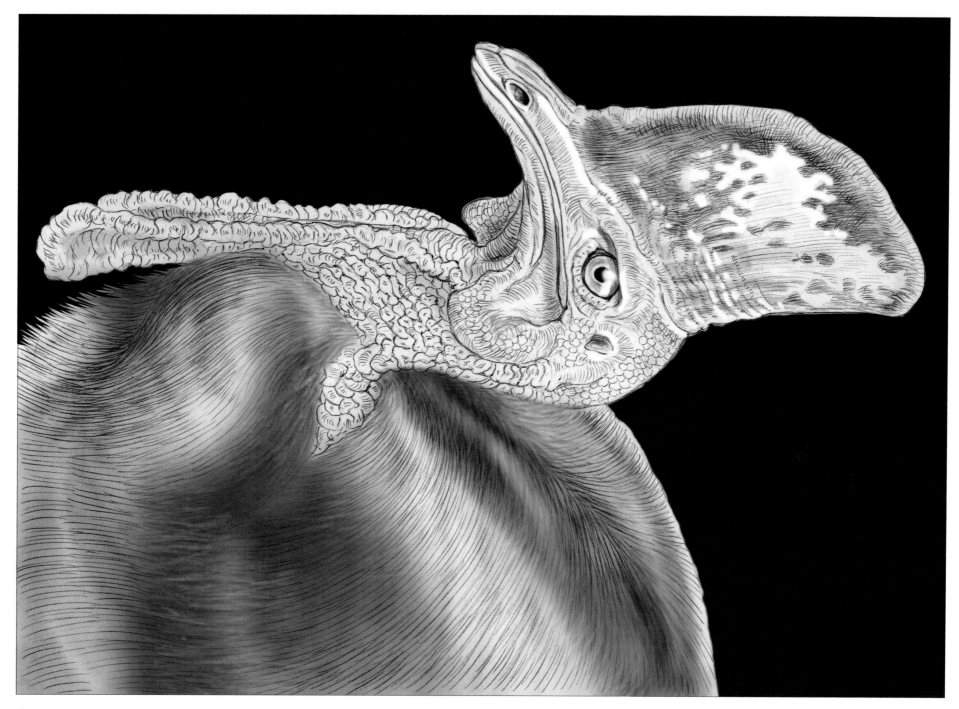

Cassowary

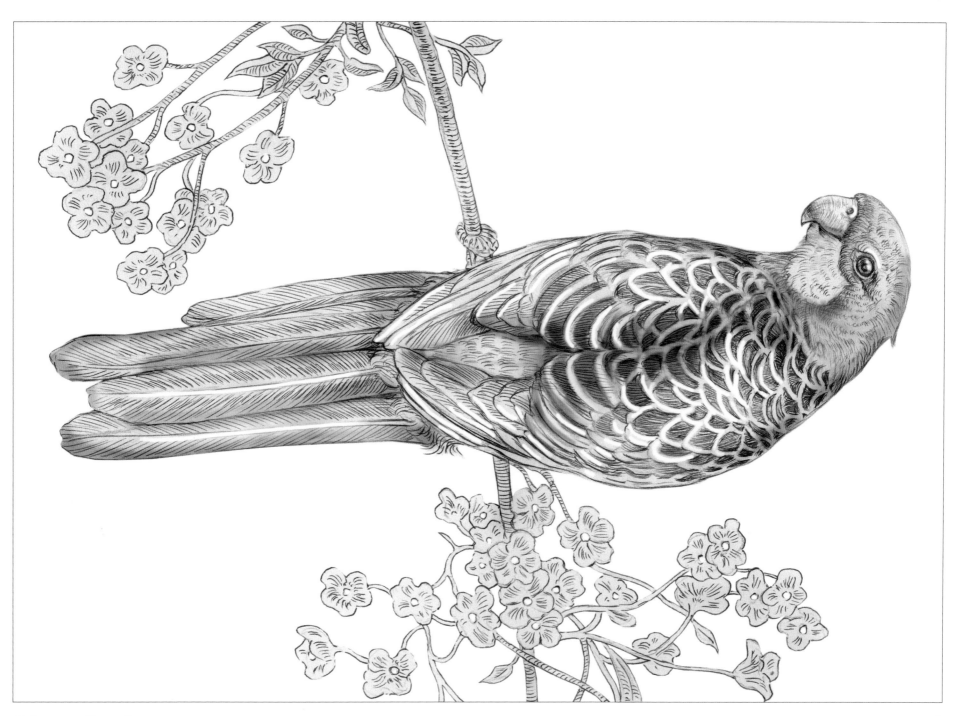

Crimson Rosella

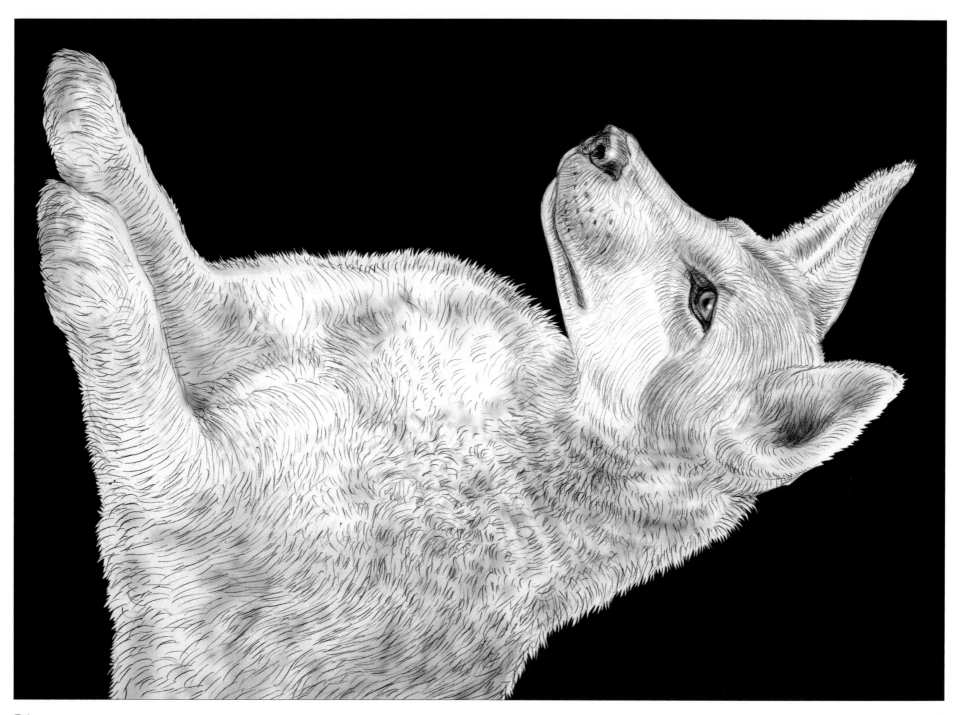

Dingo

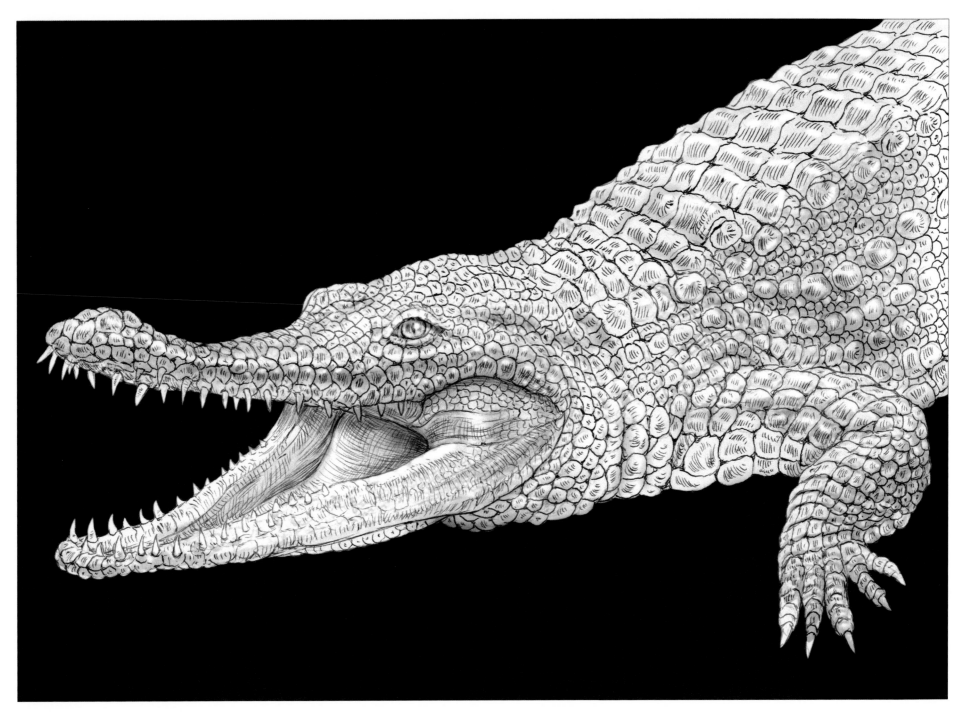

Freshwater Crocodile

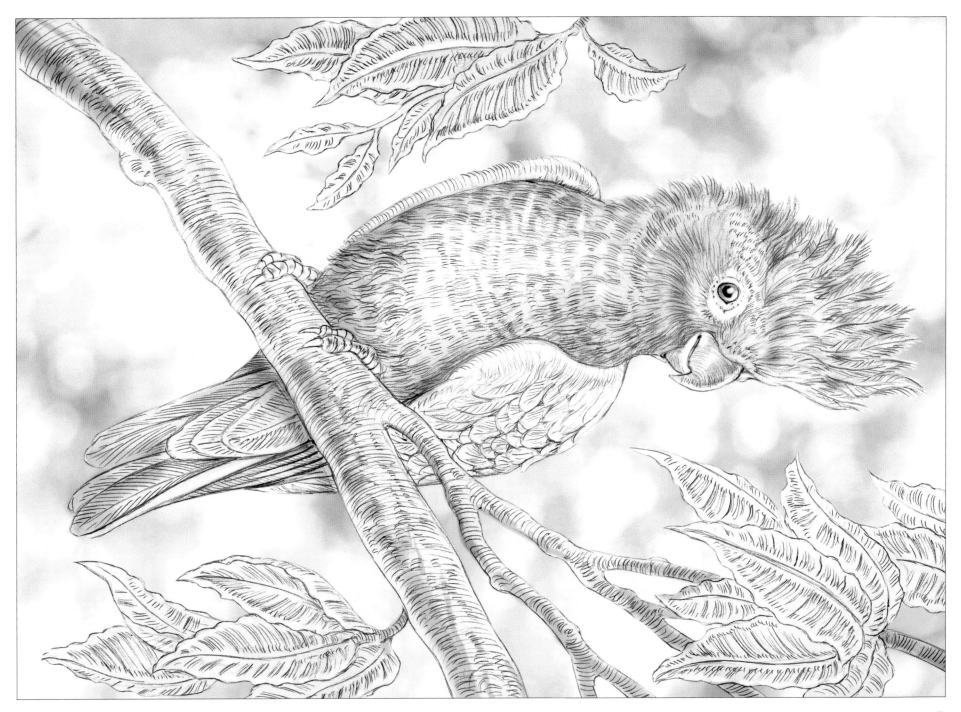

Galah

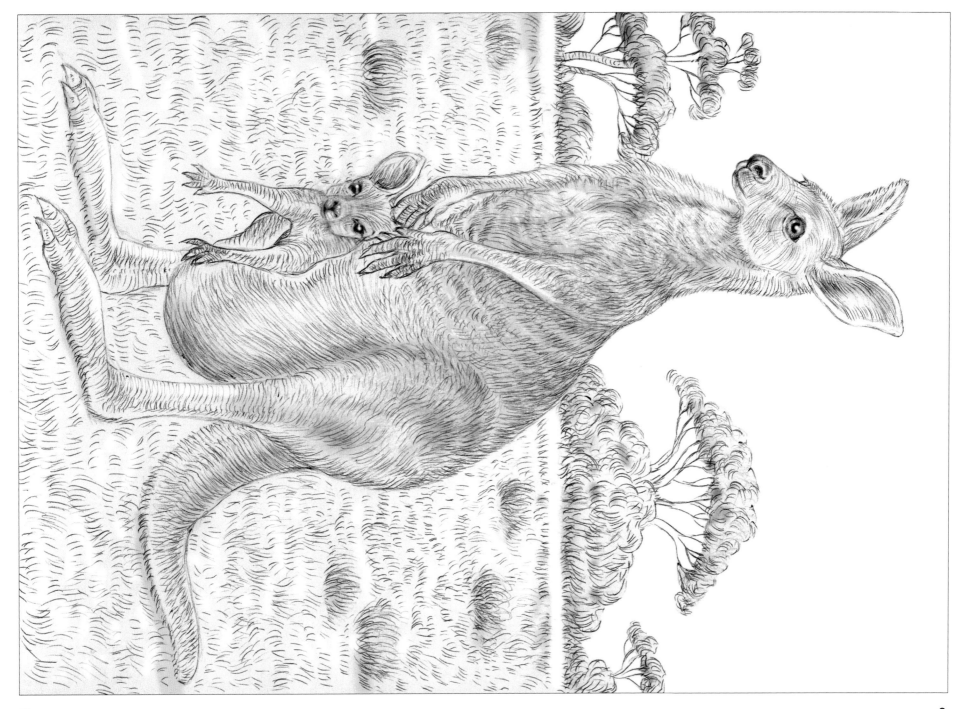

Kangaroos

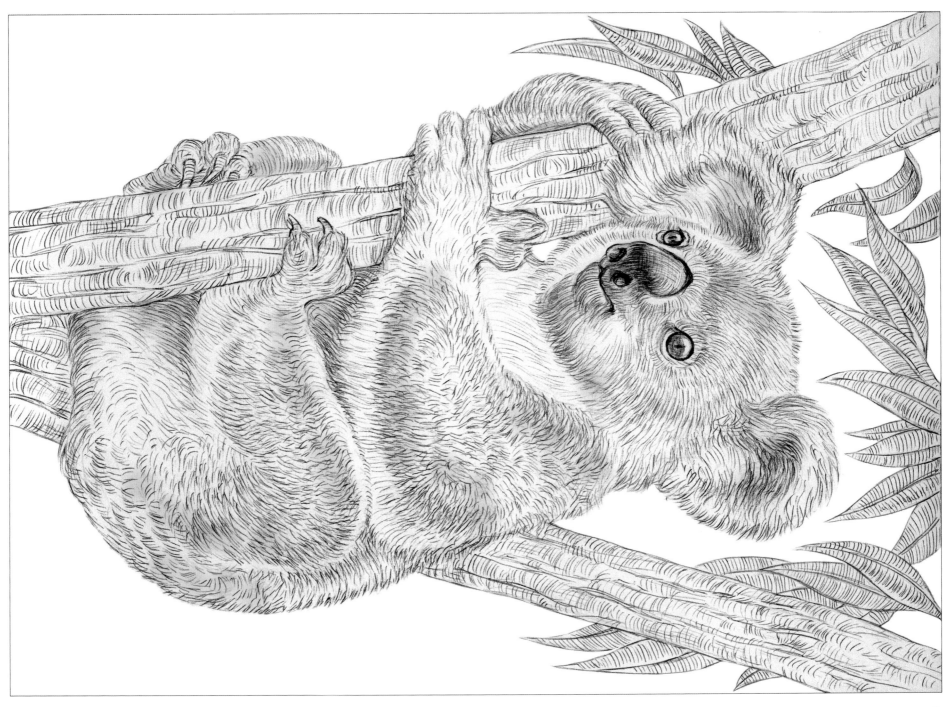

Koala

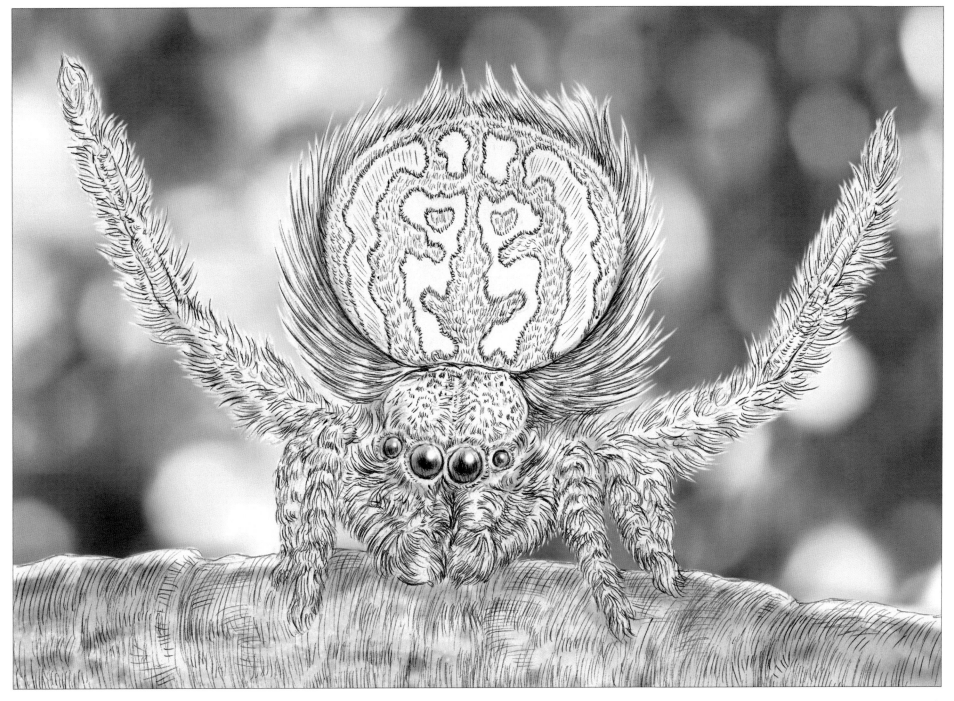

Peacock Spider

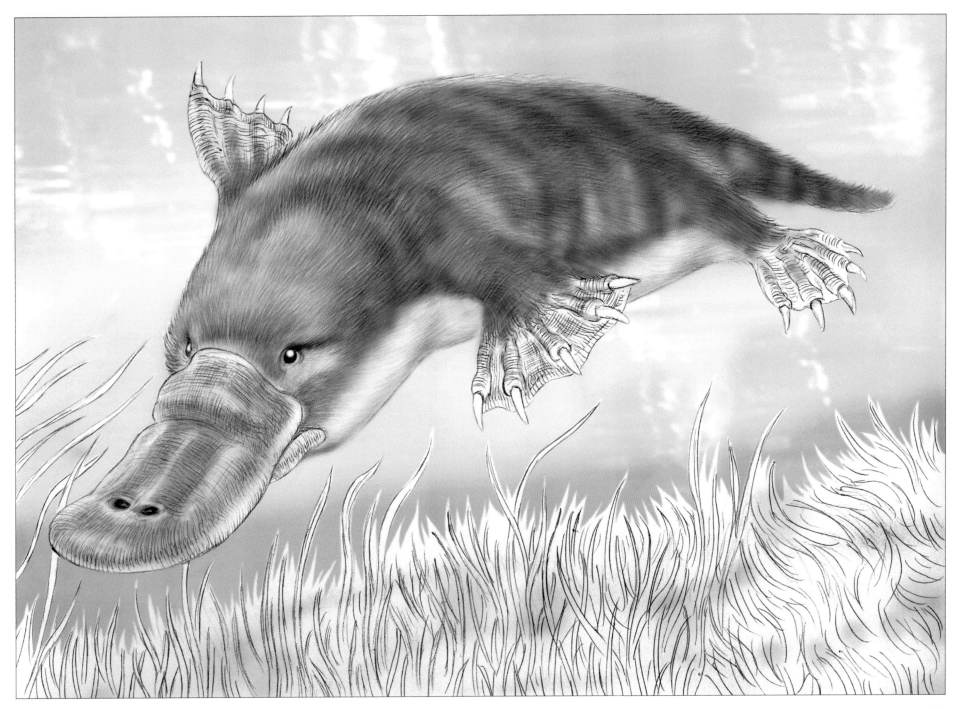

Platypus

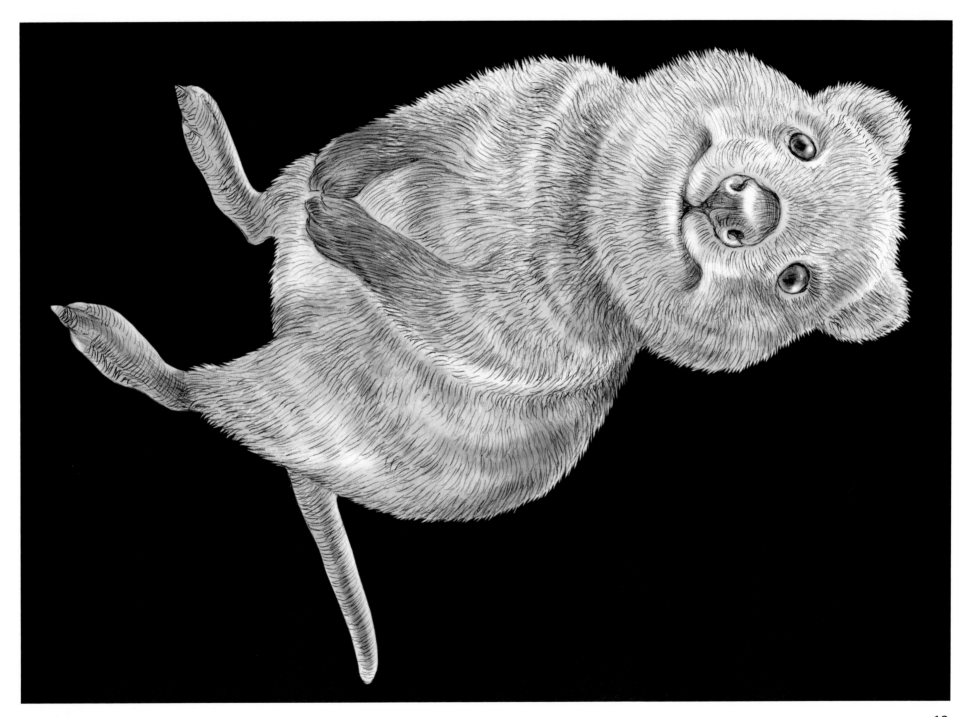

Quokka

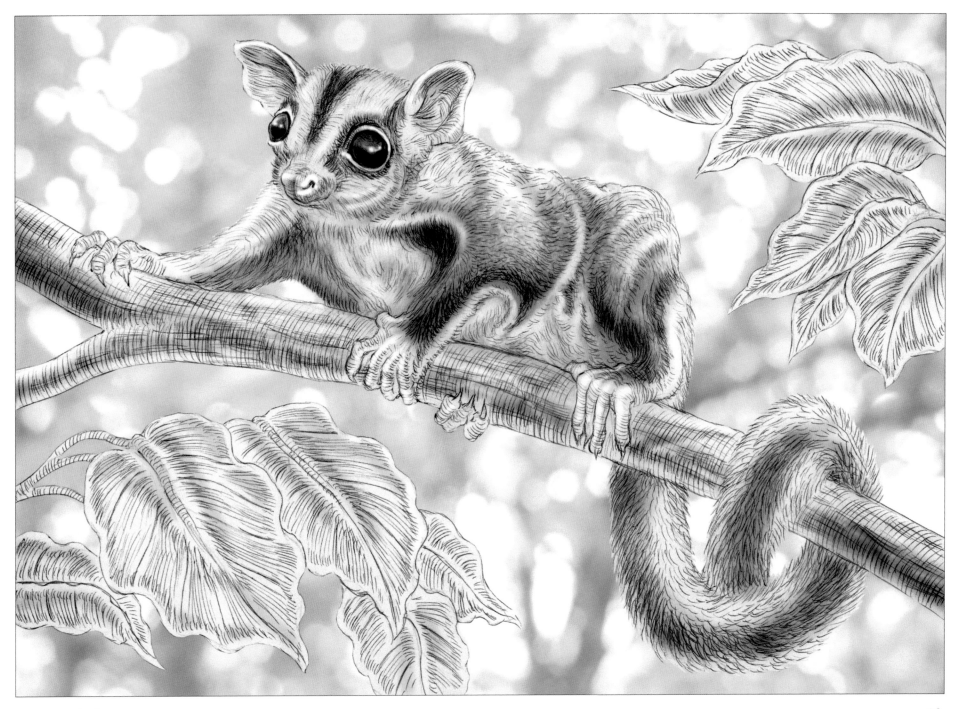

Sugar Glider

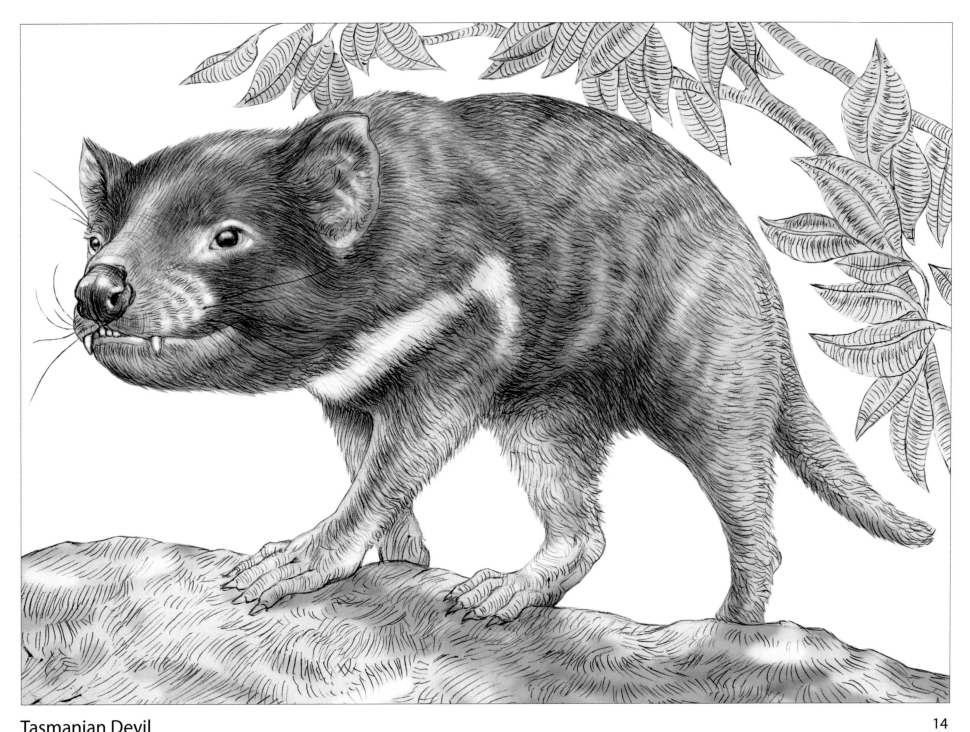

Tasmanian Devil

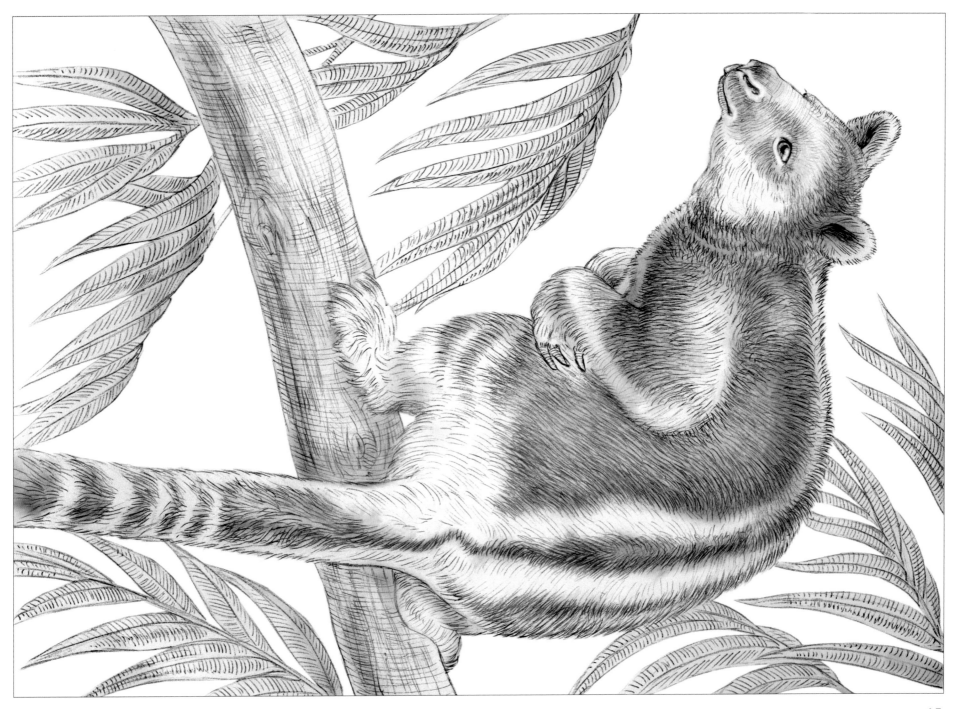

Tree Kangaroo

15

Tim Jeffs is a New York City based artist and illustrator who has been creating dynamic artwork for over 25 years. Animals are a favorite subject matter of his, along with the complex and intricate details these creatures possess. *"The incredible diversity and complexity of animals has always intrigued me. They offer endless pleasure to look and marvel upon. In every drawing I try to capture the unique quality of each particular animal. I hope you enjoy my perspective, love and admiration of these incredible creatures."*

Visit my website for prints, digital coloring books and coloring lessons:

www.TimJeffsArt.com

Discover the full line of Tim Jeffs' Published Coloring Books

Intricate Ink Animals In Detail Volume 1, 2 3 and 5, and Intricate Animal Drawings Volume 1 and 2 are available at:
Amazon.com
Bookdepository.com

Colouring Heaven Collection Endangered Animals
Available at: Colouringheaven.com

Discover Tim Jeffs' Merchandise

Etsy Shop
www.etsy.com/shop/TimJeffsArt

Society6 Shop
www.society6.com/TimJeffsArt

Redbubble Shop
TimJeffsArt.redbubble.com

TeePublic Shop
https://www.teepublic.com/user/tim-jeffs-art

Discover the full line of Tim Jeffs Digital Coloring Books at:
www.TimJeffsArt.com

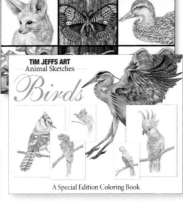

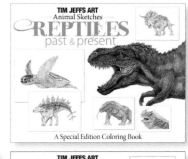

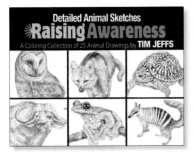

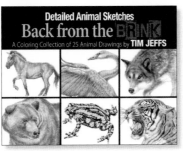

And Coloring Lessons

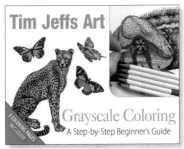

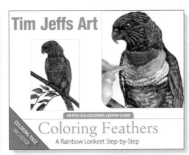

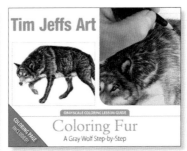

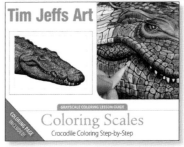

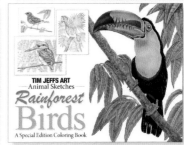

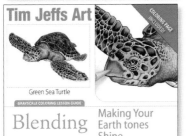

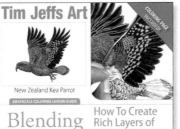

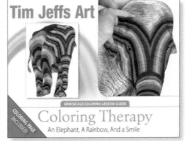

TIM JEFFS ART Online Resources

Share Your Creativity with the World!

Join the ever-expanding coloring group of animal lovers who inspire each other through their colorings of the animals from Tim's books and lessons. With thousands of members from all around the world, Tim's Facebook group "Intricate Ink Coloring Group" is a creative and safe space where everyone is welcome. Jo Warren, the groups all-inspiring administrator will welcome you in with open arms and is there to encourage everyone to just have fun no matter your coloring skill level. Come join, we can't wait to have you as a member! Join Tim's Facebook Coloring Group at:

www.facebook.com/groups/intricateink

Visit the Home of Tim Jeffs Art

TimJeffsArt.com is my home on the web where I display all of my work and various projects. I hope you can stop by for a visit! You'll find my new shop where signed and unsigned prints of all of my animal drawings are available to purchase, along with the complete library of my digital download coloring books and grayscale coloring lessons. In the conservation section, you can see the projects that I am very proud of. Using my art to preserve wildlife is so important to me.

www.TimJeffsArt.com

Printed in Great Britain
by Amazon